THE PORTFOLIO

How to Make a Photography Portfolio in 9 Easy Steps

ALECIA RENECE

Copyright © 2019 by Alecia R. Harrison

All rights reserved. This book or any portion thereof

may not be reproduced or used in any manner

whatsoever

without the express written permission of the

publisher

except for the use of brief quotations in a book

review.

Printed in the United States of America

First Printing, 2019

Alecia Renece Photography

www.aleciarenecephoto.com

Dedication

This book is dedicated to all of the artists out there trying their best to make good use of the gifts God has given them.

This is for the Artists struggling to call themselves Artists, for the Artist trying to make a living off of their art.

For the Artist longing to have their art appreciated and felt.

I see you. I feel you.

May your art be honest, your heart be pure and your business be profitable.

THE PORTFOLIO

9 | Introduction

11 | Step 1: Niche Down

16 | Step 2: How To Define Your Style

18 | Step 3: How To Plan Your Shoot

32 | Step 4: "The Shoot"

34 | Step 5: Take A Break

35 | Step 6: Culling

36 | Step 7: Editing

39 | Step 8: Rinse & Repeat

40 | Step 9: Share Your Portfolio

46 | Congratulations!

www.aleciarenecephoto.com

Introduction

So you want to start making money from your art by taking on photography clients, but you need a portfolio. It can sound really intimidating and you may not know where to start.

Never fret, my friend. Putting together a portfolio is so much easier than you think it is. Anyone can put together a portfolio, even if you have never taken on any clients in the past.

I have put together an easy to follow, 9 step guide for photographers at any level. From the beginner with not much work and experience to the much more seasoned photographer, I show you the easy way to build the portfolio that attracts your dream clients.

You ready to build a professional portfolio?

Let's dive in!

Step 1: Niche Down!

With so many genres of photography out there, it can be super easy to be overwhelmed and even ignorant of all of your options.

At first, you may want to shoot everything and that's totally fine. However, while you're building your portfolio you need to pick a niche for the work that would most likely appeal to your desired clients.

Let's say that I am a restaurateur looking for photographers to shoot for my menu options. If you look to be hired for me for that job I am going to ask to look at your portfolio. When you present your work to me, I'll be looking to see if you're a good fit for my restaurant business.

If your portfolio is filled with portraits, landscapes, architecture and food, I'm going to be turned off. Your clients are only interested in looking at photos that are going to help them build their precious business.

Having all of the extra photos in your portfolio comes off as unprofessional and can make you look like you are a jack of all

trades (which, sadly, many businesses don't like).

Even if you are skilled at shooting many different genres, make it relevant to your client. You want to show them that you are just as invested in their businesses' success as you are.

Pick a Genre

Okay, so how do you figure out what genre of photography you should be shooting to build your portfolio?

You want to think long term. The portfolio you build and showcase on your website and on social media, will be the clientèle you attract. If you love shooting portraits, show more portraits. If you hate dealing with models or people one on one, maybe consider something else like product photography.

Overall, you want to pick a genre that is going to make you happy in the coming months and even years. You can always change your mind later, but you want to pick a genre of photography that is going to bring you joy and the right kinds of clients.

Umbrella Genre

The best way to figure out what you want to shoot, is by asking yourself two questions. The first question should be, "What photos do I enjoy looking at?"

What is your favorite genre? How does it make you feel? Why are you so drawn to that form of media?

You don't want to pick a genre just because it's trendy. Trends end, my friend and you don't want to be stuck years down the road in a career you took up just because it's trendy. That will not sustain you.

Pick a genre that you are absolutely taken with. Pick one that lights your fire, evokes emotion, pierces your heart. That will be the genre you LOVE.

Then ask yourself the second imperative question which is, "What would I like to communicate with my art?"

Do you like storytelling? Then documentary or lifestyle photography may be the best genre for you. Do you like to share stylistic inspirations? Then high fashion portraiture may be your calling. Do you love food and drink? Then food photography may be your desired niche.

SubGenre

Once you have your umbrella genre of Photography picked, now it's time to consider your Sub Genre of photography.

A niche is a specific focus of a business, brand and even art form. For example, it's not enough just to say that I'm a portrait photographer because that can mean many things. If I want to really stand out in my business, I want to pick out a sub genre within my portrait niche.

Portraiture deals with people, at its base. But you'll find that there are many sub genres in the portraiture field. You can take lifestyle styled photos of couples cuddling with one another on a Sunday afternoon, documentary style portraits of women giving birth, you can shoot sensual boudoir portraits… the list goes on and on.

Do your research to decide. Pinterest is a great tool to use to gain insight and inspiration for photographers. Save what catches your eye, even if they are two opposing genres. You never know how you can link the genres together and even start your own sub-genre of photography!

 Need some ideas to get those juices flowing? Here's a very limited list:

* Portrait
 * Newborn
 * Family
 * Boudoir
 * Maternity
* Landscape
 * Flowers
 * Rivers
 * Mountains
 * Cityscape
* Business and Branding Photography
 * Headshots
 * Product
 * Food
 * Small Businesses
* Event
 * Wedding
 * Nightclubs
 * Concerts
 * Sports Games
 * Festivals
 * Conferences

See? There are ENDLESS opportunities to develop your subgenre focus. You can even niche down from some of these topics like Lifestyle Pet Photography. You literally have the power to create a career that you love.

Step 2: Consider Your Shooting Style

Experiment and Explore

This is the fun part. Now that you have your genre down, it's time to play around with your shooting and editing style.

Still using Pinterest, save photos to a board specifically focused on some editing styles and point of views that inspire and draw you in.

Then, in your spare time try shooting different subjects experimenting with these different shooting styles.

You can play with documentary style photography where you are less involved in scenes and just take photos of life as it truly is. Or you can be much more involved in your shooting process by directing the models, or setting up a food photography scene.

Again, choose the styles that brings you the most joy and be ready to use that in the actual photo shoot (more on that later) that will build your portfolio.

This may seem tedious and even a bit unnecessary, but future

clients will book shoots with you based on your unique and individualized eye. You want to make sure you're taking time to develop the eye that will set your work apart from other photographers.

This may take some time, but make sure you're leaving room to truly consider this. You don't want your art to look like a carbon copy of someone else. Along with deciding what your subgenre will be, your shooting and editing style are equally as important.

Step 3: Plan Your Shoot

The time has come my friend. You've done the research, you've experimented, you have a pretty good grasp on the type of photos you'd like to create.

Congratulations. This is no easy feat.

Not it's time to actually plan your shoot. This advice is not one size fits all. Feel free to tailor make this to fit whatever genre and subgenre you'd like to shoot. Here are some things to consider while you plan your shoot.

Resources

A few things you should consider when you're thinking your shoot are your resources. What do you have access to today? It can be easy to feel like you're unable to build a quality portfolio without all of the equipment and resources that photo studios and photographers further along in their journeys have.

If all you have to use today is a smartphone or camera, don't

be discouraged. I have shot many photos using JUST my camera or camera phone. You just have to learn to make the most of what you have, now and work your way up to an ideal situation.

If you're working with minimal resources, you may feel like you need a three light setup with reflectors and the works. That couldn't be further from the truth. If you only have a camera, no worries. God gave us the best lighting of all-- the sun.

You can use a window or go outside. There are always workarounds to "limits". If you want to recreate a more intricate photoshoot, use hacks and tutorials. If you don't have money to invest in a reflector, you can always buy a piece of white cardboard, which does the exact same thing. You can even do post production editing in Lightroom and Photoshop.

Does your shoot require a backdrop? How much is that going to cost you? If you're low on funds, consider shooting against a white wall. If you want the works and have the resources to get them, be my guest. Just be sure that you consider what you need and how much it's going to cost you to carry it out.

There are also many tutorials on how to create your own photography backdrop or scenes. YouTube has been my GREATEST resource for that.

Does your shoot require hair and make-up? Do you know any friends who are, at least, half decent at doing hair and make-up? Sometimes all you have to do is ask. Or watch some YouTube videos and learn how to do it yourself.

In the beginning of your career, you'll be learning how to do a LOT of things on your own. It can be daunting at first, but over time, you get better at it. Or you can decide to not be bothered with it at all (I prefer more natural looking photography).

Don't allow the allusion that you have no resources as an excuse to not shoot. Even though you may not have everything you think you need for a shoot, understand that less is more. You have access to everything you need as long as you have a camera.

Sometimes you just have to get a little creative.

Location

There are many things to consider in terms of completing a photo shoot, but location is key. Location determines everything; how much light you'll have access to, how much

space, the time you'll be able to shoot...

As I mentioned earlier, if you have minimal resources, your best bet is to shoot outside or use natural light. Depending on your skill level, subject or subgenre, you may need a studio for studio styled shoots.

Now, I know some of you may think that you have to book a super fancy and expensive studio to get quality shots and that's just not true. There are so many other creative places that you can have a photoshoot.

Remember what I said about getting creative? Well, it's time to sit and brainstorm some other options for our shoot. Sometimes locations are right under our noses and we don't even realize it.

If you're shooting portraits and have lighting equipment, you can rent a room in your local library for a few hours for cheap. I have rented a room for 2 hours for a grand total of $100! For two hours I was able to shoot four of my clients to build my portfolio.

If you're able, you can also rent an Airbnb. Now this option is good for lifestyle shoots and other types of portraiture as well. You can shoot an in-home photoshoot without having to clean

your home or your models clean their own. Because you can rent overnight, you have the option of having a two day photoshoot, packed with different models or various scenes. Then afterwards you can relax and hang out in a space you rented.

If you are leaning more towards product or food photography, you can use small spaces in your own home. A table and natural light are all you need to capture gorgeous food photos. And all you need is some bright and even light to capture beautiful products. These shoots take up almost no space at all and can be done with little to no fuss.

Are you interested in business and branding photography? If you aren't shooting a business owner in action in their own work space, consider shooting clients in a space related to their work. For example, if you are taking photos of a writer or blogger, capture them in a cafe typing away at their tablet. Or shoot in a library with them thumbing through a book. Or get them at a desk writing their next Best Seller. Again, creativity is your best friend.

Time of Day

For every genre of photography, it's really good to consider the time of day you'd like to shoot.

If you're a landscape photographer shooting a mountainous region, you may want to go location scouting at different points of the day to determine when the mountains look the most majestic as the light shines on them.

For shooting natural light portraits, you would want to avoid shooting in high noon to avoid harsh shadows and to avoid your model from squinting in your photos.

If you wanted to get some street photography of people, depending on where you live, you probably don't want to shoot around prime time work hours. On the contrary, if you have a model on the street and want a shoot with as little people in the background as possible, you'll probably want to avoid rush hours or busy weekends and holidays.

Keep all of this in consideration when putting together and planning your shoot.

Model/Subjects

Now, this is the fun part. Now that you have the logistics out of the way, it's time to consider your model(s) and subject(s).

Portraits

Let's begin with portraiture. You may think you need to be able to hire professional models which would cost an arm and a leg. If you live in a place that is not a city, you may not even know where to even begin looking for them.

There is a workaround that you may not even be thinking about. Do you have friends? Then you have models! So many photographers get their best practice in shooting their friends. Your friends are usually down to just hang out with you, so it won't be as awkward as meeting and entertaining a new model, and they usually aren't hard to please (if you have good friends anyway).

I had a photoshoot with my friends in my mother's living room and all we did was order food and talk.

You can post on Facebook letting people know that you're looking for models for whichever subgenre you're shooting. You'd be surprised how many people volunteer (even for Boudoir photos).

You can also word it in a way that would get people interested; "Free Photoshoot Giveaway", perhaps. Who doesn't like free? This will definitely get you eyes on your request and remove the pressure of having to be a great artist in the process.

Even if you don't have any friends, you have yourself. I love shooting self portraits. This is especially helpful because you can experiment and try different angles and looks at nobody's expense but your own. All you need is a Tripod or flat surface and a countdown timer or remote trigger for your camera.

And when all else fails, you may have to do the brave thing and shoot strangers. I know this can be scary for some people (like me) who are shy and hate rejection. However, I made myself go out and take pictures of strangers and got a surprising amount of people who were actually up for a photograph. I even made an entire series on shooting strangers.

Need some inspiration? Look up Humans of New York. It's such an inspirational series of a photographer taking photos of strangers. It's beautiful.

Product

If you're looking to start shooting product photography, you can start with items you already have in your house. Seriously.

I know that can seem silly, but why purchase something expensive to shoot for your first trial run. The truth is that brands probably aren't going to just send you their products to shoot in good faith. They want to know that they're investing money into their company by providing them with quality images.

The best way to do that is by shooting products you use regularly and that you believe in. Do you drink coffee? Research some branding shots for other coffee companies for inspiration and shoot your coffee the way you want to.

Have a FitBit? Maybe get a friend and take some product photos with a runner in action. Again, you have so much access to the things around you that will help you in putting your portfolio together.

Food

The truth is, you can make Eggo Waffles look fancy with the right photographs.

For this genre of photography, think of items you can cook and

have access to in your own fridge or cabinet and decorate the scene beautifully. Again, there is so much inspiration out there online, in magazines and on Pinterest. Use these resources to create an inspirational board for your own work.

Maybe you even know someone who can really cook. They don't have to be a gourmet chef, now. They can be your Mother or a friend. It's all about presentation when it comes to food photography.

You can even visit your local bakery, restaurant, coffeeshop, etc. and offer the FREE photos for their business. It's a win win situation. They get free photos and you get practice. They literally have nothing to lose.

Again, you can wow clients with oatmeal if it's plated nicely enough.

Landscape/Cityscape

For this category, I would start off by seeking out some free parks and landmarks where you're allowed to set up a tripod and just shoot.

Sometimes you don't need a new location to start shooting. Just shoot where you are; you local neighborhood or city or

state park. If you can capture the beauty there, then you can capture it anywhere.

The beautiful thing about this genre is that it doesn't require much of anything to get started. The landmarks and cities are already (and mostly permanently) there. You just have to worry about showing up when the weather and time of day is right.

You should also consider the time of year, as well. You'd hate to miss a beautiful shot because tourists are in your way.

Payment/Trade

Some people avoid shooting with people because they think they'll have to pay models or locations, and I totally understand. The thing is, there are people out there who are building their career, just like you. There are models looking to build their portfolio and all they want in return for their time are the edited photos from the shoot.

Yes. Seriously.

Go on Craigslist and see. There are so many models who

would like photos, but can't afford some photographers' fees. So, they look to find aspiring photographer to work with so they can help the photographer build their craft and get some shots of them as well.

This is a great thing for you because the pressure is off. Because money isn't in the equation, you don't have to feel the pressure of over delivering to your client and neither do the models. You're both in the beginning stages and you're both growing as artists.

If you don't have money for models, make-up artists, cook, etc. Think of some creative ways that you can trade with them so it's as equally beneficial for them as it is for you.

Here are some ideas:

- Free use of your photos
 - Their Portfolios
 - Their menus
 - Etc.
- Credit wherever you share your photos
- Client Recommendations and Referrals
- A Free Meal
- Help with something else you're good at
- Your undying love and appreciation.
- Etc. Get Creative!

Prepare & Back Up Plan.

Keep in mind that things don't always go as planned.

Your model can get sick or drop out. It may rain on the day you want to shoot outside. Your equipment could break. An annoying police many may say that you can't shoot there (even when you know you can).

The point is anything can happen. The best thing to do is to already be prepared for any foreseen issues. If it ends up raining on the day you'd like to shoot, then have a backup date ready just in case. Make sure everyone involved is available on both of those days.

Or, if you're really up for a challenge, see if you can make lemonade out of lemons by having a rainy day as the backdrop to your shoot instead of the bright and clear one you had envisioned.

It's always helpful to to remain resilient in the time of crisis or chaos as an artist. Nothing goes exactly how we plan. Sometimes it's better and sometimes it's worse.

Also be sure to bring things you think you'll need on your

shoot. Is it sunny and hot? Bring water and napkins or a towel. It also may be helpful to have the make-up artist on set just in case the makeup melts off of your subject's face.

Bring safety pins in case your model has a wardrobe malfunction.

Bring a step stool. You'll never know when you need to take some great shots from above your subjects.

Think about the things you may need on your set, because things can go wrong when we fail to prepare.

Step 4: "The Shoot"

Now, I want you to shoot EVERYTHING. Shoot anything that brings you joy. Try out every angle, refer to your pinterest board or where ever you keep your inspiration and try everything. I just want you to be considerate of time.

This is important especially if you're working with models for trade. Even though they have offered themselves to your art and vision, you still want to be respectful of their time. Money can come and go, but time is an invaluable resource.

Agree with your model before hand on how long it will take, what time you will start and what time you will finish and honor that time. If you do well with honoring the time, you may even be able to work with them in the future because you didn't drag the shoot out longer than it needed to be or start late or end late.

Set your alarms and start when it says start and finish when it says finish.

You also want to set a timer for yourself. It can be really easy to become frustrated with your work and burnt out if you go too long on the first go round.

Start by giving yourself an hour to shoot, taking a break and shooting for another hour. This way, you won't be so tired and burned out by the end of the shoot.

I want you to LOVE what you do, not loathe it.

Thank everyone for their time and consider thank you cards. I know it can seem dated, but letting them know that you took an extra step in thinking about them will go further than you know.

Step 5: Take A Break

Now, this is just my personal opinion, so take it with a grain of salt.

It's really easy for me to get burned out with my work. I become overwhelmed with the process of shooting and editing and I tend to procrastinate. Wheat this was telling me was to take a break.

There is so much work that goes into planning for a photoshoot and actually carrying it out. By the end of my shoot, my muscles are tight and sometimes sore. Though I love what I do, I've also learned to value rest.

Rest allows you to put some space in between your work and you. It also gives you fresh and rested eyes to look at your artwork and edit them well.

Take at least 3 days to rest your eyes and then begin the culling and editing process.

Step 6: Culling

Culling is the process in which you choose which photographs you love (LOVE is key here) and archive or get rid of the others.

The best way to do this that I've found is to upload all of the photos I've taken and go through them one-by-one.

I give myself 3 seconds of looking at the photos and decide whether I absolutely Love them or not. Just give yourself 3. If you give yourself more than that, then you'll end up keeping more than you need.

Don't think about it too much. Your heart knows whether it likes it or not.

And don't worry about it if you only get three solid ones you love. Stay true to your choices. You'll have more opportunities to build your collection.

Step 7: Editing

Now this process is totally up to you. There are so many different editing styles out there that it'd be way too difficult to name them here. It's all based on your personal preferences.

What I can do is recommend software that I have personal experience with.

For those just getting started out, I'd definitely recommend Adobe Lightroom. This takes care of basics. We're talking color correction, simple blemish corrections and many other features. It's a pretty good starting base.

For those who are more advanced, I would recommend Adobe Photoshop. Here you can edit almost ANYTHING you'd like from the adding backgrounds that aren't there, changing the size of something... the possibilities are endless.

There are other programs out there for your use, so feel free to check those out too. I've heard good things about them, but I'm only going to recommend to you what I have personal experience with.

For inspiration on editing styles, again, check out YouTube (I

call it YouTube University). There are tutorials for almost ANYTHING out there and any style. Do you have a photographer whose style you admire who is pretty well known? You can literally search "Edit Like..." and enter the photographer's name and multiple videos may come up for that editing style.

Be sure not to just copy their style, but be inspired by it. Add your own flare or adjustments. This will set you apart from the other photographers in your sub genre.

You have so many more resources than I did when I first started. The possibilities are endless.

What I want to say is that you should experiment with different editing styles in the beginning. Save different versions of the same photo to compare what you like and dislike about them. But as you mature in your process, try to hone in on one style of editing for your clients.

Your style of editing can always change, but clients like to see a portfolio of the same kind of work so that they know what to expect in their photos.

We love creativity, but clients are drawn to us because of our eye and our editing styles. They have an idea of what their end

product should look like, and may be disappointed if you present them with a totally different editing style than you were selling them.

It's like if your favorite cereal changed their ingredients and flavor. You may hate it or you may love it. There's no telling.

At the end of the day, you are selling your client an experience , but also a product. You don't want to be advertising something you don't deliver.

Step 8: Rinse and Repeat.

To build a portfolio of diverse images; different subjects that show the breadth of your talent, you're going to have to continue this process until you get about 25 - 50 quality images.

This way you can showcase your talent to potential clients and they have more photos to consider when deciding if they should go with you or consider someone else, which is abslutely normal.

You don't want to appeal to everyone. You want to the right kind of clientele that loves and trusts your work.

Step 9: Share The Portfolio

Ladies and Gentlemen, the moment you all have been waiting for. It is time to put together your portfolio.

I'm so proud of you. You have done so much work and the world deserves to take a peek into your talent and skill.

Portfolio Platforms

All a portfolio is is a showcasing of your work. There are many places that you can showcase your work especially with the advent of technological advances.

In the past, in order to showcase your photos, you may have walked around with your photos printed in a folder to show your potential clients.

You still can do this, but your ability to showcase your work would be really limited. With technology today, you can share and showcase your work in a matter of seconds.

You have multiple options that you haven't considered or counted because they may not be "professional".

Your Website

Now, it's not really a surprise that you should showcase your work on your website above any other place. Your website should host all of your photography things when it comes to your images, booking, events and everything else.
You should be proudly showcasing your work on a dedicated page strictly labeled "Portfolio" as well as having them sprinkled throughout your website.

Blog

Much like your website, you should be utilizing a blog on your website to keep up with some of your most recent works. No matter what you do, your work will evolve and interests will change. Bring people along for that journey.

You can allow people to see how well you're improving and bring in new clients who love your work.

An added bonus of utilizing a blog is that it increases your website's SEO. This just means that it will improve your ability to be found on the internet.

So yes. Use your blog!

Social Media

Are you using your social media platforms to showcase your best work? If you aren't you definitely should be.

We use social media everyday, and don't get the use we need to boost our creative works. We'll post our thoughts opinions and lunch, but won't post our photos. It is one of the most underused and overlooked portfolio of them all.

That's right. Your social media feed can be your portfolio. Use it!

Sign up for an account strictly for your photography business and start posting your best works. Be sure to use hashtags related to your niche and locations to help other clients, models and even other photographers find you better.

Feel how you feel about social media. There are definite downsides to it, nut I have gotten many inquiries about photo shoots from my Instagram, alone than my website. Don't waste this opportunity to grow your business because of your personal opinions around social media.

Social media makes you much more accessible and is actually an easier way to get in contact with brands in your niche as

well!

Be sure to tag your models and everyone who helped with the shoot as well. Share and spread the wealth. We all can make it! They may also repost the photos which would give you even more exposure.

One of the best platforms to showcase your art, in my opinion, is Instagram. It's such a visual platform and easy to tag locations and people in the photos.

Another good platform to use is Pinterest. You can post your work on the site with your description of the photos and location. This will bring people to save your images and even visit your website.

I also enjoy Facebook and Twitter as a stunning image can break up the monotony of the texts in the platform.

One Pagers

When you get inquiries about your photography, you'll want to have a collection of samples available for the clients ready to be sent. These samples are what I like to call one pagers.

One pagers have the details of the shoot (the price, amount of

time, what the client can expect) as well as samples of the photography they can expect.

I have a one pager for every service that I offer.
Here is a sample. You can format them any way you want:

Sample Folder

Do you remember the physical folder I mentioned earlier in this chapter? You can recreate the same concept and deliver those images to your clients digitally and instantly.

All you have to do is create a folder filled with 15 - 25 images of your best work in that specific niche. So I'm not putting in pet portraiture in the same folder as Newborn portraiture. You're giving each one a separate folder based on what your client asks for.

Then you can send a zip file to your client when they inquire about your services in an instant.

You want to make sure that you're updating your portfolio every couple of months. You will improve the more you shoot and edit. You'll also begin to really hone into your personal

style as a photographer.

It's always better to be prepared, than to have to scramble around looking for new photos to send.

Congratulations

Congratulations, friend. You have officially created a solid portfolio of work. Your hard work has and will continue to pay off.

One word of advice: Don't feel stuck in your career.

The beauty of a portfolio is that you can continue to rebrand and rebuild your body of work to more reflect your style and your desires.

You don't have to keep the same portfolio. In fact, you can create many different portfolios within your desired niche, or try your hand at new niches you've yet to try.

The possibilities are endless. You just have to take advantage of them.

Happy Snapping, Friends.

The world needs you.

I believe in you!

Alecia Renece is a Multi-Passionate Artist, Storyteller, Lover and Friend. Her ultimate goal in life is to inspire and encourage others to love their lives, their art and themselves.

www.aleciarenecephoto.com

Instagram: @AleciaRenecePhoto

Facebook: Alecia Renece Photography

www.ingramcontent.com/pod-product-compliance
Lightning Source LLC
Chambersburg PA
CBHW030736180526
45157CB00008BA/3193